Cover:
8. *Old Country Bazaar*

13. *Adolescence*

The Paintings, Drawings, and Lithographs of

William S. Schwartz
(1896–1977)

Hirschl & Adler Galleries, Inc. New York, N.Y.
November 24–December 29, 1984

Grand Rapids Art Museum, Michigan
February–March, 1985

Illinois State Museum, Springfield
September 9–October 29, 1985

State of Illinois Art Gallery, Chicago
November 11–January 6, 1986

ACKNOWLEDGMENTS

Cooperation and assistance from a number of individuals helped to bring this exhibition to fruition. Phyllis and Robert Helford of Des Plaines, Illinois, the step-daughter of the artist and her husband, and Bernard M. Dresner of Paris, France, Schwartz's step-son, kindly lent family papers and memorabilia for research. Their personal recollections and Schwartz anecdotes filled biographical gaps; their constant encouragement and optimism were invaluable. Louise Dunn Yochim, whose firsthand knowledge of Chicago artists is extensive, lent her unpublished manuscript, "The Life and Work of William Samuel Schwartz," for the purpose of research, and offered her own colorful reminiscences of the artist. At Hirschl & Adler Galleries, Robert Schonfeld located the estate and acquired it for the gallery; Susan Menconi read through the galleys and introduction with perceptive editorial eyes; Kathleen Calio assisted with the final typing and organization of the introduction. In Chicago, Illinois, Courtney Donnell, Assistant Curator of 20th Century Paintings and Sculpture at the Art Institute of Chicago, was helpful in matters of research. Robert J. Evans, Curator, and Maureen A. McKenna, Assistant Curator, at the Illinois State Museum, in Springfield, with an auxiliary branch in Chicago (run in association with the Illinois Arts Council), have taken the show for both museums. M. McKenna also provided pertinent research material during the initial stages of this project.

D.D.

INTRODUCTION

At the age of seventeen William Samuel Schwartz emigrated from Smorgon, Russia, to America. The reasons for his departure were political and religious, and, in part, because members of his family had already settled in the United States. Little is known about his early life, and he seldom spoke about it. He was born on February 23, 1896, and began to study art at age six. His precocious interest in art resulted in a four-year scholarship to the Vilna Art School, Poland, from 1908 to 1912. After completing his course of study, he left the small Russian hamlet of Smorgon in 1913 for New York City.

Some fifty-seven years later, Schwartz nostagically recalled his first impressions of America, as seen through the naive and idealistic eyes of a teenage youth:

> I expected to find America big and free and busy. I thought to find the streets, if not actually paved with gold, at least metaphorically surfaced with semiprecious materials, for America...meant opportunity....I was utterly unprepared for my first impression of America. That impression, in one word, was POWER! The sheer physical bulk of New York engulfed me. The drive and clamor of the city echoed in my ears. What size was here! What boldness, and scale, and wealth, and lavishness! Most of all, what strength was symbolized by the city and its thunder! On every side, what pace, what power!...I have never out grown that first impression registered more than 40 [sic] years ago....[1]

Schwartz assimilated the culture of America as though he were one of her most loyal denizens. While outwardly he never regretted having left his native birthplace, youthful recollection were to remain indelible in his memory. Later, when he became a prominent Chicago artist and an American Scene painter, he never lost touch with his Russian heritage and an affinity to nature. For this reason, the development of Schwartz's work over the course of sixty-four years, from his arrival in America until his death in 1977, reveals a fascinating dichotomy. Schwartz's artistic infatuation with American culture was often tempered by an internal grappling with his own history. At various points in his career—never compromised by commercial concerns—both facets of his personality coalesced. This is particularly true of his earliest work, from the 1920s, which comprises the bulk of this exhibition, but examples can be found throughout his oeuvre. Whenever he discussed his life and career, Schwartz began with his arrival in America. But apparently his Russian past was never forgotten; its pictorial reappearance was a truer sign of its psychic significance and gave his best work depth and poetic intensity.

Schwartz spent his first eight months in America living with his sister in New York City. He worked briefly in an alarm factory before realizing that New York, for one newly arrived and speaking very little English, was not the place to begin an art career, and, in 1915, moved out West to join his brother Max in Omaha, Nebraska. He was fortunate to have members of his family in various cities; they quickened his cultural acclimation. Arriving in Omaha, he procured work as a house painter and a newspaper delivery boy for the *World-Herald*. While renewing his study of art by attending the Kellom School in Omaha, he found a friend and mentor in J. Laurie

Wallace.[2] Under Wallace's tutelage he studied life drawing and portraiture, and devoted himself to painting.

In 1916 Schwartz left Omaha for Chicago, Illinois. After six months, unable to find adequate employment, he returned to Omaha. His goal, however, was to enter the Art Institute of Chicago. He returned to Chicago a second time, the same year, worked at various jobs to support himself, and eventually gained admittance to the Art Institute. During this time, while taking courses in portraiture, life study, and painting, he also sang as a principal tenor for vaudeville, radio, concert, and operatic productions.[3] Music played an important part in Schwartz's early career; with the money he earned performing with the Bohemian Opera at the Studebaker Theatre, on the Orpheum Circuit, and with the Chicago Symphony Orchestra he was able to defray his general cost of living and to continue his education at the Art Institute. A dual career continued throughout the 1920s; the press favorably reviewed his concerts and recitals in Chicago and the Midwest. Given his musical success, he could have pursued a singing career, but from the start he saw it only as a means to support his art:

> . . .I started singing under Karl Stein and Francesco Daddi. I sang in roles and on many stages. Music. . .was my second language. Music was also my introduction to many Americans of Italian and Bohemian origins. It was, in addition, my introduction to small towns, and slow trains, and the exciting feel of audiences the country over. But music was my second language only. My first career was, and remains, painting.[4]

By the late 1920s, when he had established a strong reputation as a painter, Schwartz discontinued musical productions. Music, however, continued to influence his painting. Harmony became the central principle uniting both disciplines. Schwartz developed a personal credo, which resulted in a series of abstract paintings titled "Symphonic Forms" begun in 1924, that reflected his aesthetic:

> All my life I have been a musician as well as a painter. In both music and art, I believe that the great thing is the creation, in an individual way, of harmony. In art, among the old masters as well as among contemporary artists, harmony may be of three sorts—of color, of form and of line. In looking at nature, therefore, I search for materials which may be interpreted and manipulated until they become unified wholes and reveal the. . .harmony. . .representative of my own personality—my thoughts and my feelings. I feel that the mastery of only one of these elements—color, form or line—is unsatisfactory. . .I strive for the simultaneous mastery of all three.[5]

Reading between the lines of Schwartz's credo, one detects an affinity to the earlier writings of Wassily Kandinsky, whose treatise *Concerning the Spiritual in Art* (1912) had also described painterly abstraction in terms of its formal characteristics and affinity to music. Kandinsky's discussion of form as "the outer expression of the inner content," his belief that form must "issue out of inner necessity," and his search for equilibrium between "the great abstraction" and "the great realism," inspired a generation of American artists, whose training had been essentially academic, to develop personal expression. His writings, as well as his art—seen by Chicago artists as early as 1913 and later in 1922 when the Art Institute of Chicago exhibited the modernist collection of Arthur Jerome Eddy—embodied an empirical search for spiritual self-expression, the quintessence of vanguard art at this time.

In his own work, Schwartz probed realism and abstraction. Both approaches were never totally divorced from each other; even in his most abstract compositions initial ideas were based on natural forms. Though circumstances at different times in his life

25. *Symphonic Forms #10*

affected which mode he preferred, together they formed a dynamic balance in his oeuvre.

Chicago in the 1920s was a focus of artistic experimentation and reform. Initially inspired by the Armory show in 1913, Chicago artists began to reject the residual classicism that had dominated since the World's Columbian Exposition of 1893. Throughout the 1920s, art that had been previously shunned and condemned as "ultra-radical" was now frequently shown by mainstream institutions. Under the progressive curatorial guidance of Robert B. Harshe and Daniel Catton Rich, the Art Institute of Chicago organized important exhibitions of modern European art.[6] The Chicago Arts Club also exhibited works by George Braque, Marie Laurencin, Auguste Rodin, Pablo Picasso, and Antoine Bourdelle in 1923, and between 1926 and 1929 gave one-man shows to Constantin Brancusi and Henri Matisse. However, in spite of these progressive exhibition programs, Chicago, as a contemporary art center, remained rather traditional and academic. Vanguard Chicago artists criticized the Art Institute for its conservative judicial policies and its choice of local artists annually represented in the *Artists of Chicago and Vicinity Show*. A staunch supporter of avant-garde Chicago art, the controversial art critic C. J. Bulliet, writing in 1930, lamented the regressive course of Chicago art following the Armory show:

> Though the Armory show excited Chicago to even more spectacular furies than it did New York, Chicago settled more comfortably back, eventually, into the bed of academicism. With all its reputation for gun-play and gangsterism, Chicago observes better the traditions and amenities.[7]

Bulliet, who began writing as drama critic for the *Chicago Evening Post* and later developed an acute eye for modern art under the influence of Rudolf Weisenborn, maintained a stormy relationship with Schwartz. To his mind, Schwartz belonged to

a "pet" clique, favored by the Art Institute of Chicago, that represented a conservative tenet of Chicago art. There ensued a colorful correspondence in the editorial columns of the *Chicago Daily News;* at one point, Bulliet's "Artless Comments" column elicited a harsh letter, jointly written by Schwartz, Ivan Albright, Aaron Bohrod, and Constantine Pougialis, condemning his attitudes and false accusations.[8]

During this period, artists discontent with the situation organized their own hanging committees and exhibitions. Various groups were founded, each with their own philosophic basis. Cor Ardens, or "Ardent Hearts," was established in 1921 as "a brotherhood of artists which is international" that held exhibitions "without juries, without prizes and without sales;" the Neo-Arlimusc Society was founded in 1926 to foster an interdisciplinary association between the fields of art, literature, music and science; and the No-Jury Society, by far the most influential organization, was founded in 1922 by Rudolph Weisenborn, Carl Hoeckner, and Raymond Jonson to counteract the restrictive policies of the Art Institute.[9] Within this milieu, tradition mixed with radicalism to forge a melting pot of diverse attitudes and individual sensibilities:

> Throughout the twenties the art scene in Chicago was a kind of grab-bag in which one could find a little bit of everything. Amid the plethora of choices the non-critical attitude made its contribution. Instead of one style or concept of "genius," artists were moved by a state of mind applicable to multiple styles and modes of procedure. The modest claim of "sincerity" came forward; and it, sincerity, determined whether a mode was to be embraced or not....[10]

Following his graduation from the Art Institute with honors in 1917, Schwartz pursued painting.[11] Except for his membership in the Chicago Society of Artists, he maintained a select group of friends, who included Ivan and Malvin Albright, Aaron Bohrod, and Anthony Angarola, and remained outside reactionary vanguard groups, such as Cors Ardens and The No-Jury Society.[12] Sympathetic to modernism, he borrowed what he needed from European vanguard art, but he remained committed to naturalism. Experimentation never superceded tight handling of form; abstraction was always balanced by the suggestion of natural elements.

When it came to having his work exhibited, Schwartz was successful early on. One year after his graduation, *In Violet* was included in the Art Institute's *Twenty-Second Annual Exhibition of Artists of Chicago and Vicinity.* His consistent inclusion in this juried exhibition—by 1923 he was represented by four paintings—culminated in his first one-man show at the Institute in 1926, a major accomplishment for a painter only thirty years old.[13] For Schwartz it signalled a breakthrough in his career. After 1926, he was given numerous solo exhibitions at museums and galleries in the Midwest and New York and was included in important group shows in New York and Washington, D.C.[14]

Between 1920 and 1931 Schwartz produced a significant body of figurative work. Full of dissonant color and strange content, these pictures shocked midwestern and eastern audiences. One critic reviewing Schwartz's show at the Municipal Art Gallery, Davenport, Iowa, in 1930, was baffled and incensed by what she saw:

> The best few are great, but the worst ones are horrid....A protracted viewing of these 14 weird canvases leads one from coherent amazement to incoherent dismay. It does not seem possible that such a collection of paintings could be hung on the stage walls and foisted upon the public as illustrative of the best in American painting today...This show caters to the particular tastes of those who have a penchant for what may broadly be termed radical art, and it is certainly not to be ignored.[15]

2. *The Pioneers*

One year later, Schwartz's first one-man exhibition at the Delphic Studios in New York was reviewed by *The New York Sun*:

> The Delphic Studios are showing the work of William S. Schwartz, an adopted son of Chicago, in whose praise the vocabulary of hyperbole has been well-nigh exhausted. So it is with a certain trepidation and awe that one makes the round of these troubled canvases. There is strength here, to be sure, but whether the artist is one of 'the outstanding figures in the new internationalism of art,' as one enthusiast [Dudley Crafts Watson] has it, is another matter. There seems in his work a trifle too much deference to several artistic favorites of the hour, ancient and modern, for that. Still there is a certain savage intensity in the work of this man—a hint of resentments and brooding sympathies with alien things that set him somehow apart....[16]

Both reviews reveal the general difficulty people had with Schwartz's early work. Considered "ultra-radical" by some and "troubled" by others, most of these canvases, fired by personal imagination and recollections, had none of the overt narrative or historic overtones that would have given them broader appeal. Instead, much of this work was a kind of personal catharsis, remembrances of a childhood long forgotten that found expression through visual metaphor and allegory.

Paintings such as *The Pioneers, Utopia, Death of a Mermaid, The Swimming Pool, Meditation, The Messenger,* and *Day Dreams* (cat. nos. 2-7, 11) do reflect an obvious knowledge of modern French painting; in particular, they recall the bold design and flat color of Paul Gauguin and the Fauve color of Henri Matisse. These works are also indebted to the poetic allegories of Arthur B. Davies, whose one-man exhibition at the Art Institute in 1920 Schwartz probably would have seen. From the French painters, Schwartz assimilated formal innovations; from A. B. Davies he saw a way to personalize allegorical narrative.

Schwartz's pioneers are searchers and pathfinders. Walkng in an endless procession, robed, bearded, and sometimes carrying a staff, they move towards the unknown. Their procession is timeless, without beginning or end. *Death of a Mermaid, Meditation,* and *Day Dreams* unfold as a vision, or dream. These paintings are

3. *Utopia (Dedicated to Romain Roland)*

personal allegories, signs of ritual passage, travel, rebirth, and utopian existence. As metaphors, they are poetic equivalents to states of mind.

Other pictures from this period are more objective recollections. *The Old Country Bazaar* and *After Working Hours* (cat. nos. 8, 14) are reconstructed from memories of people and places once familiar. In both, the rustic village, or "shtetl," becomes a powerful reminiscence. Its inhabitants, strangely unidentified with backs turned, or depicted as generic types facing frontally, are pictorially separated from the viewer. The entire village seems to heave and contort, affected by the pathos of time and distance.

Schwartz's acceptance of industry and technology as vital signs of American culture was never superceded by his deep respect for nature and humanity. Though he embraced the mechanistic, he also lauded the simplicity of natural environs. In his art, both themes appeared sometimes together. One of the earliest instances of this reconciliation corresponded to a progression away from allegorical symbolism towards a more straight-forward realism. In *Adolescence* (cat. no. 13), mankind, symbolized by nude figures surrounded by a utopian landscape, is dominated on the horizon by factories and smoke stacks. Was Schwartz suggesting here a compatibility between nature and technology, or did *Adolescence* symbolically imply passage from utopian simplicity to urban materialism? The contrast between the two worlds is striking; their ultimate compatibility, uncertain. In spite of its ambiguous overtones, *Adolescence* signalled a thematic transition in Schwartz's work as it developed in the late 1920s. After 1926, the artist painted American scene subjects more frequently, replacing his former obsession with allegory and figurative symbolism.

Corresponding with this thematic shift, Schwartz also began to paint abstractions. Begun as early as 1924 and continued until his death, a series of "Symphonic Forms" was inspired by his love for music and provided a more internal expression. In a 1932 newspaper interview printed in *The Chicago American,* Schwartz expounded upon the character of his "Symphonic Forms":

> Viewing these paintings is like listening to music, but it is the spectator who 'makes' the music. The painter has set down the notation, like any composer, using the whole vocabulary of the graphic arts as medium. But just as the score of a symphony is not a symphony, so the separate forms on each canvas are not the painting.
>
> In combining these forms into harmonious compositions I am giving life to the score, and the result is a symphony of forms...this is the style towards which my art has tended from the beginning.[17]

Though "Symphonic Forms" were begun as early as 1924, none was exhibited publicly until 1935, when, along with lithographs, they comprised the bulk of a one-man exhibition at the Art Institute of Chicago. In general, each of these paintings was titled with its generic name, "Symphonic Forms," and numbered consecutively. From the very beginning of his career, Schwartz was methodical about labelling and numbering his work, and he maintained a ledger book in which each painting was meticulously recorded. Through his efforts and the efforts of Mona Turner, who became Schwartz's wife in 1939 and selflessly took over all administrative responsibilities, we know every painting and lithograph he ever executed: its title, date, and, in the case of paintings, its exhibition and publication record. With the "Symphonic Forms" series, Schwartz painted sixty-six canvases from 1924 to 1967. *Symphonic Forms #s 9, 10, 16,* and *17* (cat. nos. 24-27) were all painted in 1932. Stylistically, their scumbled surfaces recall figurative work from the same period, but their content is a combination of natural forms and geometric shapes arranged through free association. Many recall landscapes; others are more abstract and dream-like. A playfulness and whimsy remind one of Kandinsky's non-objective compositions. Inspired by music

28. *Symphonic Forms #18*

and poetry, which Schwartz listened to or had Mona read to him while painting, this series enabled the artist to focus on the formal aspects of his art and to paint entirely for himself. Subjective and personal, this series fulfilled a vital niche in his oeuvre and reflected his natural propensity to paint from an internal response to his environment.

In 1928 Schwartz began to investigate lithography. Though he worked in this medium for only ten years, from 1928 to 1938, he produced a significant body of prints. Consistent with his careful record-keeping, each print was given a chronological number and an impression number. From the records he kept during this period, we know that he executed a total of sixty lithographs, pulled in editions that varied from sixteen to seventy-three impressions. The range of his subjects and method of working varied. In some cases, a conté crayon drawing served as the preliminary study for a print, as, for example, in *The Gas Factory, Female Torso, Sitting Nude,* and *The Dancer* (cat. nos. 36, 42-44). In other cases, a print was based on an earlier painting, as in *Dwelling along the River* and *The Old Monastery Wall,* which became *Lithograph #s* 10 and 42 (cat. nos. 47, 53). By and large, however, lithography offered Schwartz the chance to extend his repertoire of subjects and to experiment with a new medium. Mastering, with subtlety, the tonal range and contrast inherent in the medium, he produced images remarkable for their elegant simplicity, draughtsmanship, and formal design. In his series of sensuous nudes, for example (cat. nos. 50, 51), the female form is brought to the threshold of abstraction by a minimum of definition. Some of the most interesting lithographs reflect strong imagination and fantasy. While the fractured surfaces of *The Gas Factory* recall the cubism of Charles Demuth or Henry Lee McFee, images such as *Lithograph #s* 16 and 41 (cat. nos. 48, 52) are futuristic, streamlined, and fantastic. This is particularly true of *Lithograph #41* (*Visionary City*). Executed in 1931, some eighteen years after he left Russia, *Visionary City* is a composite recollection of Schwartz's life, past and present. Fields and houses from his Russian youth are transformed into an urban cityscape full of skyscrapers capped with Russian minarets, bringing the flash-back full-cycle. Schwartz could often lapse into a reminiscence that mixed past with present and future. However, as the 1930s progressed, he became more concerned with the problems of a nation racked by depression; his central reality became the fate of a country to which he felt deeply beholden.

The difference between Schwartz's work from the early 1920s and the 1930s reflects a transition from the internal world of dream and reminiscence to the external world of political consciousness. His strong connection to the American scene at this time was reinforced by socio-economic conditions and government-sponsored employment. Speaking about his work in general, but referring specifically to his initial discovery of America and Americans, Schwartz recalled:

> ...looking back over a period of more than four decades, I realize, now, that I was completely unprepared for the two most important and enduring influences America was to have upon me and my work....They were aspects unknown in Europe—or at least unknown to me. In my personal discovery of America they must rank as discoveries I made myself. They came to me as a total surprise.
>
> My first discovery was the astonishing beauty and vitality of the American scene. No one had told me I could expect to come upon such fresh and moving subjects for brush and canvas. No one had ever hinted at the variety of the American landscape, at the range and richness of American coloration, at the number and interest of themes on every hand. I have spent most of my life painting my response to the American scene....
>
> My second discovery of America was a re-discovery in point of time and development with the first....It was, and is, my discovery of Americans themselves....
>
> People are people, of course, the world over. But Americans are, nevertheless, a special kind of people, similar and yet how different from the European pattern.

52. Lithograph #41
(Visionary City)

The thoughts behind American faces, the characters I have tried to transfer from life to canvas, the men and women of many callings and many regions who have sat for me all bear the unmistakable new world stamp. I have tried to paint this human essence of America in the major media just as I have tried to recapture the atmosphere of her woods and waters, her cities and towns, her plains and hills.[18]

During the 1930s Schwartz painted murals for numerous post offices in Illinois under the Treasury Department Section of Painting and Sculpture.[19] The subjects of these murals relate historically to their geographical and architectural settings. The three panels depicting *Transportation of Mail* (cat. nos. 29-31) were some of the earliest examples of this genre. As studies, these were intended as viable ideas, but, in this case, were never executed full-scale. Between 1935 and 1943, Schwartz also executed easel pictures and lithographs under the Works Progress Administration's Federal Art Project. Having participated earlier in "The Chicago Artists' Committee for W.P.A. Jobs," along with his close friends Ivan Albright and Aaron Bohrod, Schwartz was socially and politically active during this period.[20] *The Hurdy-Gurdy Man, A Countryside,* and *Come to Me All Ye That Are Heavy Laden* (cat. nos. 20, 21, 32) embody a nervous tension and conscious distortion, and reflect an Americana spirit that infused his work from the late 1920s on. In a final summary of his artistic career, Schwartz enumerated facets of the American scene that inspired his art:

Looking back...I have painted the country quite literally from Maine to California. I have painted landscapes and waterscapes: the clear, cool greens of Deer

County in Wisconsin, the sculptured epics in stone which are the Black Hills, the perfect little villages of New England; prairie towns (clapboard and stucco), cities (brawling and turbulent), farms and mines and deserted houses and immense factories.

I have painted Americans: men at work and leisure, fishermen, farmers, share-croppers, hill billies and city billies, the country over. I have talked with the subjects of my paintings: old men with faces as secret and vital as the meaning of life; young fellows, reckless and confident; substantial citizens, men diligent in their business; women, city and country, mothers and grandmothers of their broods....

I have painted things in America: minerals, driftwood, flowers, foliage, exterior and interior compositions. I have painted abstracts and symbols. I have painted non-objective creations and symphonic forms.[21]

For Schwartz painting always remained a personal quest to probe beneath the surfaces of his subjects to their essence. Recollections of the past and their nostalgic transformation, a vital aspect of his work, was paralleled in spirit by the work of Marc Chagall. Chagall's Russian roots also profoundly influenced his oeuvre; his attitude towards abstract painting and acute observations on early impressions that forged his artistic sensibilities represents a striking association. Chagall observed:

What I mean by "abstract" is something which comes to life spontaneously through a gamut of contrasts, plastic art at the same time as psychic, and pervades both the picture and the eye of the spectator with conceptions of new and unfamiliar elements....

The fact that I made use of cows, milkmaids, roosters, and provincial Russian architecture as my source forms is because they are part of the environment from which I spring and which undoubtedly left the deepest impression on my visual memory of any experiences I have known. Every painter is born somewhere. And even though he may later respond to the influences of other atmospheres, a certain—a certain "aroma" of his birthplace clings to his work....[22]

Like Chagall, Schwartz was deeply affected by his Russian past. However, to say that he was obsessed with this past would belie a subtle but salient characteristic of his work. Ultimately, the work's poetry generated from its humanity; through art he found his own destiny within the greater history of mankind.

October 6, 1984 Douglas Dreishpoon

NOTES

1. William Samuel Schwartz, "An Artist's Love Affair with America," in *Chicago Tribune Magazine*, April 5, 1970, pp. 64-65.

2. J. Laurie Wallace (1864-1953) had been a pupil of Thomas Eakins' at the Pennsylvania Academy of the Fine Arts, Philadelphia, before moving to Chicago, Illinois. When the Omaha Art School (Omaha Academy of Fine Art) was founded in 1891, under the auspices of the Western Art Association, Wallace moved from Chicago to Omaha to serve as its director and distinguished teacher. He also ran his own private atelier, and when financial difficulties caused the dissolution of the Western Art Association and closed the Omaha Art School, Wallace remained in Omaha and taught classes until his death.

3. Schwartz's operatic performances and recitals were favorably reviewed as early as 1917 (in the *Chicago Evening Post*) and continued to be reviewed until 1929, when he discontinued public appearances. From 1917 to 1929 his repertoire included productions of *La Favorita, The Bartered Bride, The Kiss, Rigoletto, La Traviata, Il Trovatore, Aida,* and *Cavaleria Rusticana.*

4. Schwartz, *loc. cit.*

5. "William S. Schwartz," in catalogue for *Exhibition of Contemporary American Paintings,* University of Illinois, Chicago, 1950, [n.p.]; reprinted in Louise Dunn Yochim's *Role and Impact: The Chicago Society of Artists* (Chicago: The Chicago Society of Artists, 1979), p. 184.

6. These included, in 1926, Arthur Jerome Eddy's collection of works by Wassily Kandinsky, Franz Marc, Constantin Brancusi, Pablo Picasso, Marcel Duchamp, and Francis Picabia; also, in 1926, Arthur B. Davies' personal collection, which included works by Henri Matisse, Picasso, Henri Rousseau, and Paul Cezanne; and, in 1929, a one-man exhibition of works by Odilon Redon.

7. C. J. Bulliet, *Apples and Madonnas* (New York: Covici, Frieda, Inc., 1930), p. 231.

8. *Chicago Daily News,* Dec. 14, 1935.

9. The No-Jury Society was the brainchild of Rudolf Weisenborn. A former student of Stanislaus Szukalski—influential teacher and political anarchist who, early on, reacted against the conservative attitudes prevalent in the Chicago art scene— Weisenborn became a leader of the modernist movement in Chicago following the Armory show. Initiated as a reaction against the conservative judicial policies of the Art Institute, the No-Jury Society invited to show all artists rejected by the Art Institute from their annual *Artists of Chicago and Vicinity* and *American Painting and Sculpture* shows. Though initially successful, given the critical support of C. J. Bulliet, the Society rapidly lost its members to the mother institution, a situation not unlike that which took place in New York twenty-nine years following the formation of the Society of American Artists in 1877, when its membership rejoined with the National Academy of Design in 1906.

10. Ethel Joyce Hammer, "Attitudes Towards Art in the Nineteen Twenties in Chicago," (unpub. Ph.D. dissertation, The University of Chicago, 1975), p. 182.

11. These honors included distinguished awards for portraiture, general painting, and life painting.

12. Anthony Angarola (1893-1929), certainly Schwartz's closest friend during their student days at the Art Institute, died unexpectedly just after he returned from Europe in 1929, having spent a year there painting on a Guggenheim fellowship. Schwartz was absolutely shattered by his death, refused to paint for weeks, and later dedicated a monumental painting to him, titled *La Commedia.*

13. Schwartz destroyed many of his earliest paintings. These included *In Violet* (1918), *The Prophet of Doom* (1919), *The Wandering Jew* (1921), *Omen* (1921), *Self-Portrait* (1921), and *The Pathos of Distance* (1922). Considering the titles of these works, one wonders whether Schwartz destroyed them because of unpleasant associations they recalled from his past.

14. Important group exhibitions included, in 1933, *49 Chicago Artists, Paintings and Prints,* at the Whitney Museum of American Art, New York; in 1933, *Painting and Sculpture From Sixteen American Cities,* at the Museum of Modern Art, New York; in 1936, *New Horizons in American Art,* also at the Museum of Modern Art; in 1937, *Ninth Biennial: International Exhibition of Watercolors,* at the Brooklyn Museum, New York; in 1939, *Biennial,* at the Corcoran Gallery, Washington, D.C., and The New York World's Fair; in 1941, *Contemporary American Water Colors,* at The Metropolitan Museum

of Art, New York; in 1942, *Between the Two Wars: Prints by American Artists 1914-1941,* at the Whitney Museum of American Art; in 1942, *Artists for Victory: An Exhibition of Contemporary American Art,* at The Metropolitan Museum of Art; in 1942, *117th Annual Exhibition,* at The National Academy of Design, New York; and, in 1944, *Annual Exhibition of American Painting,* at the Whitney Museum of American Art.

15. Florrie Ann Tams, "Weird Canvases in One-Man Art Show Carry Message of Ultra-Radicalist—Schwartz," in *Davenport Democrat and Leader,* March 21, 1930, p. 13.

16. "Schwartz and Massaguer at the Delphic Studios," in *The New York Sun,* Oct. 29, 1931, p. 12.

17. Meyer Zolotareff, "Music Caught in Painting," in *The Chicago American,* Sept. 17, 1931.

18. Schwartz, *loc. cit.*

19. These included murals for post offices in Fairfield, Eldorado, and Pittsfield, Illinois, titled, respectively, *Old Settlers* (1936), *Mining in Illinois* (1937), and *Champ Clark Bridge* (1938). Prior to his post office murals, Schwartz painted a mural titled *Mining* for the General Exhibitions Building at the Chicago Century of Progress Exposition, in 1933; in 1935, for the Cook County Nurses' Home, he painted *Chicago,* and for the Glencoe Public Library he painted *American Musicians.*

20. Maureen A. McKenna, Introduction to *After the Great Crash: New Deal Art in Illinois* (Springfield: Illinois State Museum, 1983), pp. 5-10.

21. Schwartz, *loc. cit.*

22. Marc Chagall, from an interview with James Sweeney, 1944, originally published in *Partisan Review,* XI (Winter 1944), pp. 88-93; reprinted in Herschel B. Chipp, ed., *Theories of Modern Art* (California: University of California Press, 1968), pp. 440-43.

14. *After Working Hours*

CATALOGUE

An asterisk * indicates that
the work is illustrated. For the dimensions
of each work, height precedes width.

All works are from the estate of the artist
unless otherwise noted.

PAINTINGS

*1. *Man Thinking*

Oil on canvas, 34 x 28 in. (86.3 x 71.1 cm.)

Signed, dated, and inscribed (at lower left
center): WILLIAM S. SCHWARTZ; (on the
back): "MAN THINKING"/BY/WILLIAM S.
SCHWARTZ/CHICAGO/1923

*2. *The Pioneers*

Oil on canvas, 34 x 51¾ in. (86.3 x 131.4 cm.)

Signed, dated, and inscribed (at lower right):
Wm. S. SCHWARTZ; (on the back): "THE
PIONEERS"/BY/WM. S SCHWARTZ/
CHICAGO/1924

RECORDED: "Schwartz's Art is Sound,
Though New," in *The Wisconsin State Journal*,
Dec. 12, 1926

EXHIBITED: The Art Institute of Chicago,
Illinois, The Art Institute of Milwaukee,
Wisconsin, The Madison Art Association,
Wisconsin, The Oshkosh Public Museum,
Wisconsin, and The Kansas City Art Institute,
Missouri, 1926-27, *One-Man Exhibition by
William S. Schwartz* // University of Nebraska,
Morrill Hall, Gallery B, Lincoln, 1927, *One-
Man Exhibit by William Schwartz*, [n.p.]
no. 54

*3. *Utopia (Dedicated to Romain Roland)*

Oil on canvas, 45 x 76¾ in. (114.3 x 195 cm.)

Signed, dated, and inscribed (at lower left):
Wm. S. SCHWARTZ; (on the back):
"UTOPIA" (DEDICATED TO ROMAIN
ROLAND)/BY/WILLIAM S. SCHWARTZ/
CHICAGO/1924

RECORDED: Marguerite B. Williams, "Little
Modernist Art at Year's Show," in *The Daily
News*, Feb. 1, 1924 // *The Detroit Free Press*,
Jan. 4, 1925, illus. // R. A. Lennon, "Shows by
Mitchell and Schwartz Varied," in *The Chicago
Evening Post Magazine of the Art World*, Aug.
3, 1926 // J. K., "Chicago Artist Exhibits Here,"
in *The Milwaukee Journal*, Oct. 24, 1926 //
"Schwartz Exhibit Startles Milwaukee," in *The
Art Digest*, Nov. 15, 1926 // "Schwartz's Art is
Sound, Though New," in *The Wisconsin State
Journal*, Dec. 12, 1926 // "Works in Oil of
Artist-Singer Are Shown at Museum," in *The
Daily Northwestern*, June 10, 1927 // Nickolas
John Matsoukas, "The Art of William
Schwartz," in *The Forge* (Feb. 1925), pp. 35-41
illus. // "Exhibit Schwartz Paintings Here," in
The Detroit Jewish Chronicle, March 27, 1931

EXHIBITED: The Art Institute of Chicago,
Illinois, 1924, *The Twenty-Eighth Annual Exhi-
bition by Artists of Chicago and Vicinity*, [n.p.]
no. 166 // Temple Beth-El, Detroit, Michigan,
1925, *Fourth Annual Exhibition of Jewish Art-
ists* // Los Angeles Museum, Gallery F, Califor-
nia, 1925-26, *First Pan-American Exhibition of
Painting*, [n.p.] no. 208 // The Art Institute of
Chicago, Illinois, The Art Institute of Mil-
waukee, Wisconsin, The Madison Art Associa-
tion, Wisconsin, The Oshkosh Public Museum,
Wisconsin, and The Kansas City Art Institute,
Missouri, 1926-27, *One-Man Exhibition by
William S. Schwartz* // University of Nebraska,
Morrill Hall, Gallery B, Lincoln, 1927, *One-
Man Exhibit by William S. Schwartz*, [n.p.]
no. 53

*4. *Death of a Mermaid*

Oil on canvas, 32 x 40 in. (81.3 x 101.6 cm.)

Signed and inscribed (at lower left): Wm. S. SCHWARTZ; (on the back): DEATH OF A MERMAID

Painted in 1924

EXHIBITED: The Art Institute of Chicago, Illinois, 1925, *The Twenty-Ninth Annual Exhibition by Artists of Chicago and Vicinity,* [n.p.] no. 171 // All-Illinois Society of the Fine Arts, Inc., Galleries of Carson Pirie Scott and Company, Chicago, Illinois, 1926, *First Exhibition by Artists of Illinois,* p. 22 no. 322 // The Illinois State Museum, Springfield, 1926-27, *The First Exhibition by Members of the Illinois Academy of Fine Arts,* p. 32 no. 283 // The Romany Club, Chicago, Illinois, 1927, *Exhibition by Members of the Illinois Academy of Fine Arts,* [n.p.] no. 135

*5. *The Swimming Pool*

Oil on canvas, 45 x 34⅛ in. (114.3 x 86.6 cm.)

Signed, dated, and inscribed (at lower left): WILLIAM S. SCHWARTZ; (on the back): "THE SWIMMING POOL"/BY/WILLIAM S. SCHWARTZ/CHICAGO/1924

RECORDED: Constance Burnham, "Art Institute's One-Man Show is a Riot of Brilliant Colors," in *The Sunday Sentinel and Milwaukee Telegram,* Oct. 24, 1926 // "Schwartz's Art is Sound, Though New," in *The Wisconsin State Journal,* Dec. 12, 1926 // "Works in Oil of Artist-Singer Are Shown at Museum," in *The Daily Northwestern,* June 10, 1927

EXHIBITED: The Art Institute of Chicago, Illinois, The Art Institute of Milwaukee, Wisconsin, The Madison Art Association, Wisconsin, The Oshkosh Public Museum, Wisconsin, and The Kansas City Art Institute, Missouri, 1926-27, *One-Man Exhibition by William S. Schwartz* // University of Nebraska, Morrill Hall, Gallery B, Lincoln, 1927, *One-Man Exhibit by William S. Schwartz,* [n.p.] no. 56

*6. *Meditation*

Oil on canvas, 16 x 20 in. (40.6 x 50.8 cm.)

Signed, dated, and inscribed (at lower left): Wm. S. SCHWARTZ; (on the back): "MEDITATION"/BY/WILLIAM S. SCHWARTZ/CHICAGO/1925

RECORDED: "Schwartz's Art is Sound, Though New," in *The Wisconsin State Journal,* Dec. 12, 1926 // "Works in Oil of Artist-Singer Are Shown at Museum," in *The Daily Northwestern,* June 10, 1927

EXHIBITED: Temple Beth-El, Detroit, Michigan, 1926, *The Fifth Annual Exhibition by Jewish Artists,* [n.p.] no. 43 // The Jewish Peoples Institute of Chicago, Illinois, 1926, *The Annual Exhibition of Jewish Painters and Sculptors* // The Art Institute of Chicago, Illinois, The Art Institute of Milwaukee, Wisconsin, The Madison Art Association, Wisconsin, The Oshkosh Public Museum, Wisconsin, and The Kansas City Art Institute, Missouri, 1926-27, *One-Man Exhibition by William S. Schwartz* // University of Nebraska, Morrill Hall, Gallery B, Lincoln, 1927, *One-Man Exhibit by William S. Schwartz,* [n.p.] no. 70

7. *The Messenger*

Oil on canvas, 42 x 36 in. (106.8 x 91.7 cm.)

Signed, dated, and inscribed (at lower right): WILLIAM S. SCHWARTZ; (on the back): "THE MESSENGER"/BY WILLIAM S. SCHWARTZ/CHICAGO/1925

EXHIBITED: The Art Institute of Chicago, Illinois, The Art Institute of Milwaukee, Wisconsin, The Madison Art Association, Wisconsin, The Oshkosh Public Museum, Wisconsin, and The Kansas City Art Institute, Missouri, 1926-27, *One-Man Exhibition by William S. Schwartz* // University of Nebraska, Morrill Hall, Gallery B, Lincoln, 1927, *One-Man Exhibit by William S. Schwartz,* [n.p] no. 57

6. *Meditation*

*8. *Old Country Bazaar*

Oil on canvas, 36 x 42 in. (91.5 x 106.7 cm.)

Signed, dated, and inscribed (at lower right): WILLIAM S. SCHWARTZ 1926; (on the back): "OLD COUNTRY BAZAAR"/BY/ WILLIAM S. SCHWARTZ/1926

RECORDED: C. H. Bonte, "122D Annual opens at Pennsylvania Academy," in *The Philadelphia Inquirer*, Jan. 30, 1927

EXHIBITED: The Art Institute of Chicago, Illinois, 1926, *The Thirty-Ninth Annual Exhibition of American Paintings and Sculpture*, [n.p.] no. 174 // The Pennsylvania Academy of the Fine Arts, Philadelphia, 1927, *The One-Hundred-and-Twenty-Second Annual Exhibition*, p. 37 no. 181 // The Chicago Culture Club, Illinois, 1927 // Bethany College of Fine Arts, Lindsborg, Kansas, 1928, *Annual Art Festival* // University of Missouri, Columbia, 1928

9. *In a Monastery Garden*

Oil on canvas, 35 x 46 in. (88.9 x 116.8 cm.)

Signed, dated, and inscribed (at lower left): WILLIAM S. SCHWARTZ; (on the back): "IN A MONASTERY GARDEN"/BY/ WILLIAM S. SCHWARTZ/CHICAGO/1926

EXHIBITED: The Chicago Galleries Association, Illinois, 1926-27, *Exhibition of Paintings and Drawings by William S. Schwartz*, [n.p.] no. 1

10. *The Fisherman's Family*

Oil on canvas, 40 x 32⅛ in. (101.6 x 81.6 cm.)

Signed, dated, and inscribed (at lower left): WILLIAM S. SCHWARTZ; (on the back): "THE FISHERMAN'S FAMILY"/BY/ WILLIAM S. SCHWARTZ/CHICAGO/1926

RECORDED: R. A. Lennon, "Show by Mitchell and Schwartz Varied," in *The Chicago Evening Post Magazine of the Art World*, Aug. 3, 1926 // Constance Burnham, "Art Institute's One-Man Show is a Riot of Brilliant Colors," in *The Sunday Sentinel and Milwaukee Telegram*, Oct. 24, 1926 // "Schwartz's Art is Sound, Though New," in *The Wisconsin State Journal*, Dec. 12, 1926 // "Works in Oil of Artist-Singer Are Shown at Museum," in *The Daily Northwestern*, June 10, 1927 // Robert Andrews, "Jewish Art to be Shown at Exhibition," in *The Chicago Daily News*, Feb. 22, 1932

EXHIBITED: The Art Institute of Chicago, Illinois, The Art Institute of Milwaukee,

12. *The Island of Illusions*

Wisconsin, The Madison Art Association, Wisconsin, The Oshkosh Public Museum, Wisconsin, and The Kansas City Art Institute, Missouri, 1926-27, *One-Man Exhibition by William S. Schwartz* // University of Nebraska, Morrill Hall, Gallery B, Lincoln, 1927, *One-Man Exhibit by William S. Schwartz,* [n.p.] no. 58 // Riccardo Gallery, Chicago, Illinois, 1964, *William S. Schwartz: A Retrospective Exhibition,* [n.p.] no. 2

11. *Day Dreams*

Oil on canvas, 9⅞ x 11⅞ in. (25.2 x 30.2 cm.)

Signed (at lower left): WILLIAM S. SCHWARTZ

Painted in 1926

EXHIBITED: The Art Institute of Chicago, Illinois, The Art Institute of Milwaukee, Wisconsin, The Madison Art Association, Wisconsin, The Oshkosh Public Museum, Wisconsin, and The Kansas City Art Institute, Missouri, 1926-27, *One-Man Exhibition by*

William S. Schwartz // University of Nebraska, Morrill Hall, Gallery B, Lincoln, 1927, *One-Man Exhibit by William S. Schwartz,* [n.p.] no. 72

*12. *The Island of Illusions*

Oil on canvas, 34¼ x 54¼ in. (87 x 137.7 cm.)

Signed and dated (at lower right): WILLIAM S. SCHWARTZ 1926

RECORDED: Nickolas Matsoukas, "Chicago is Chicago in its Thirty-Second Exhibit at Art Institute," in *The Daily Maroon,* Feb. 24, 1928

EXHIBITED: The Art Institute of Chicago, Illinois, 1928, *The Thirty-Second Annual Exhibition by Artists of Chicago and Vicinity,* [n.p.] no. 214

*13. *Adolescence*

Oil on canvas, 36 x 40 in. (91.4 x 101.6 cm.)

Signed, dated, and inscribed (at lower left): WILLIAM S. SCHWARTZ; (on the back): "ADOLESCENCE"/BY/WILLIAM S. SCHWARTZ/CHICAGO/1926

EXHIBITED: The Chicago Galleries Association, Illinois, 1926-27, *Exhibition of Paintings and Drawings by William S. Schwartz*, [n.p.] no. 10 // The Art Institute of Chicago, Illinois, 1927, *The Thirty-First Annual Exhibition by Artists of Chicago and Vicinity*, [n.p.] no. 205

*14. *After Working Hours*

Oil on canvas, 38 x 48 in. (96.5 x 122 cm.)

Signed, dated, and inscribed (at lower left): WILLIAM S. SCHWARTZ; (on the back): "AFTER WORKING HOURS"/BY/ WILLIAM S. SCHWARTZ/CHICAGO/1927

EXHIBITED: The Art Institute of Chicago, Illinois, 1927, *The Fortieth Annual Exhibition of American Paintings and Sculpture*, [n.p.] no. 190 // Des Moines Association of Fine Arts, Iowa, The Nebraska Art Association, Lincoln, and The Kansas City Art Institute, Missouri, 1928, *The Annual Exhibition of American Paintings and Sculpture*

15. *Study for "The Old Monastery Wall"*

Oil on canvas, 10 x 12 in. (25.4 x 30.5 cm.)

Signed, dated, and inscribed (at lower left): WILLIAM S. SCHWARTZ; (on the back): "STUDY FOR OLD MONASTERY WALL"/ BY/WILLIAM S. SCHWARTZ/CHICAGO/ 1927

RECORDED: Harry Wood, "Angles, Kaleidoscopic Colors Shock, Please Art Lovers," in *The Daily Cardinal*, Nov. 30, 1929

EXHIBITED: The Art Institute of Chicago, Illinois, 1929, *Exhibition of Paintings and Lithographs by William S. Schwartz*, [n.p.] no. 14 // The University of Wisconsin, Assembly Room of the Memorial Union, Madison, 1929, *An Exhibition of Paintings by William Schwartz*, [n.p.] no. 38 // The Little Gallery, Cedar Rapids, Iowa, 1930, *An Exhibition of the Progressive Art of William S. Schwartz, Modernist*, [n.p.] no. 13 // Municipal Art Gallery, Davenport, Iowa, The Oshkosh Public Museum, Wisconsin, The Kansas City Art Institute, Missouri, The Museum of Fine Arts, Houston, Texas, The Public Art Gallery, Dallas, Texas, and University of Nebraska, Lincoln, 1930-31, *Paintings and Lithographs by William S. Schwartz*

*16. *The Old Monastery Wall*

Oil on canvas, 30 x 36 in. (76.2 x 91.5 cm.)

Signed, dated, and inscribed (at lower left): WILLIAM S. SCHWARTZ; (on the back): "THE OLD MONASTERY WALL"/BY/ WILLIAM S. SCHWARTZ/CHICAGO/ 1927; (on the stretcher): OLD MONASTERY WALL

RECORDED: Olga Schatz, "The Art of William Schwartz and Raymond Katz," in *Chicago Jewish Chronicle*, May 9, 1941, p. 12

EXHIBITED: Bethany College of Fine Arts, Lindsborg, Kansas, 1928, *Annual Art Festival* // University of Missouri, Columbia, 1928

17. *The Storage House*

Oil on canvas, 24 x 20 in. (61 x 50 cm.)

Signed, dated, and inscribed (at lower right): WILLIAM S. SCHWARTZ; (on the back): "THE STORAGE HOUSE"/BY/WILLIAM S. SCHWARTZ/CHICAGO/1928

RECORDED: Harry Wood, "Angles, Kaleidoscopic Colors Shock, Please Art Lovers," in *The Daily Cardinal*, Nov. 30, 1929 // Florrie Ann Tams, "Weird Canvases in One-Man Art Show Carry Message of Ultra-Radicalist—Schwartz," in *Davenport Democrat and Leader*, March 21, 1930, p. 13

EXHIBITED: University of Wisconsin, Assembly Room of the Memorial Union, Madison, 1929, *Exhibition of Paintings by William Schwartz*, [n.p.] no. 40 // The Little Gallery, Cedar Rapids, Iowa, 1930, *An Exhibition of the Progressive Art of William S. Schwartz, Modernist*, [n.p.] no. 15 // Municipal Art Gallery, Davenport, Iowa, The Oshkosh Public Museum, Wisconsin, The Kansas City Art Institute, Missouri, The Museum of Fine Arts, Houston, Texas, The Public Art Gallery Dallas, Texas, and University of Nebraska, Lincoln, 1930-31, *Paintings and Lithographs by William S. Schwartz*

18. *Dwellings along the River*

Oil on canvas, 36⅛ x 40⅛ in. (91.7 x 101.9 cm.)

Signed, dated, and inscribed (at lower center): WILLIAM S. SCHWARTZ; (on the back): "DWELLINGS ALONG THE RIVER"/BY/ WILLIAM S. SCHWARTZ/CHICAGO/1928

19. *Butterflys #1*

Oil on canvas, 36 x 40 in. (91.7 x 101.6 cm.)

Signed, dated, and inscribed (at lower right): WILLIAM S. SCHWARTZ; (on the back): "BUTTERFLYS #1"/BY/WILLIAM S. SCHWARTZ/CHICAGO/1928

RECORDED: Manuel Chapman, *William S. Schwartz: A Study* (1930), p. 55 illus.

20. *The Hurdy-Gurdy Man*

Oil on canvas, 36¼ x 40 in. (92.1 x 101.6 cm.)

Signed, dated, and inscribed (at lower center): WILLIAM S. SCHWARTZ; (on the back): "THE HURDY-GURDY MAN"/BY/ WILLIAM S. SCHWARTZ/CHICAGO/ 1929/PAINTING #185

RECORDED: Florence Davies, "The American Section," in *The Detroit News,* Oct. 27, 1929 // Letter, John Andrews Myers (Secretary, Pennsylvania Academy of the Fine Arts) to William Schwartz, Nov. 7, 1929 (unpub. ms., Schwartz Papers, Des Plaines, Illinois) // Letter, Frances Barney to William Schwartz, Dec. 17, 1929 (unpub. ms., Schwartz Papers, Des Plaines, Illinois) // Manuel Chapman, *William S. Schwartz: A Study* (1930), pp. 178, 183 illus.

EXHIBITED: Carnegie Institute, Pittsburgh, Pennsylvania, 1929, *Twenty-Eighth International Exhibition of Paintings,* [n.p.] no. 118 // Pennsylvania Academy of the Fine Arts, Philadelphia, 1930, *The 125th Annual Exhibition of Paintings and Sculpture,* p. 36 no. 223 // The Art Institute of Chicago, Illinois, 1931, *Thirty-Fifth Annual Exhibition by Artists of Chicago and Vicinity,* [n.p.] no. 192

1. *Man Thinking*

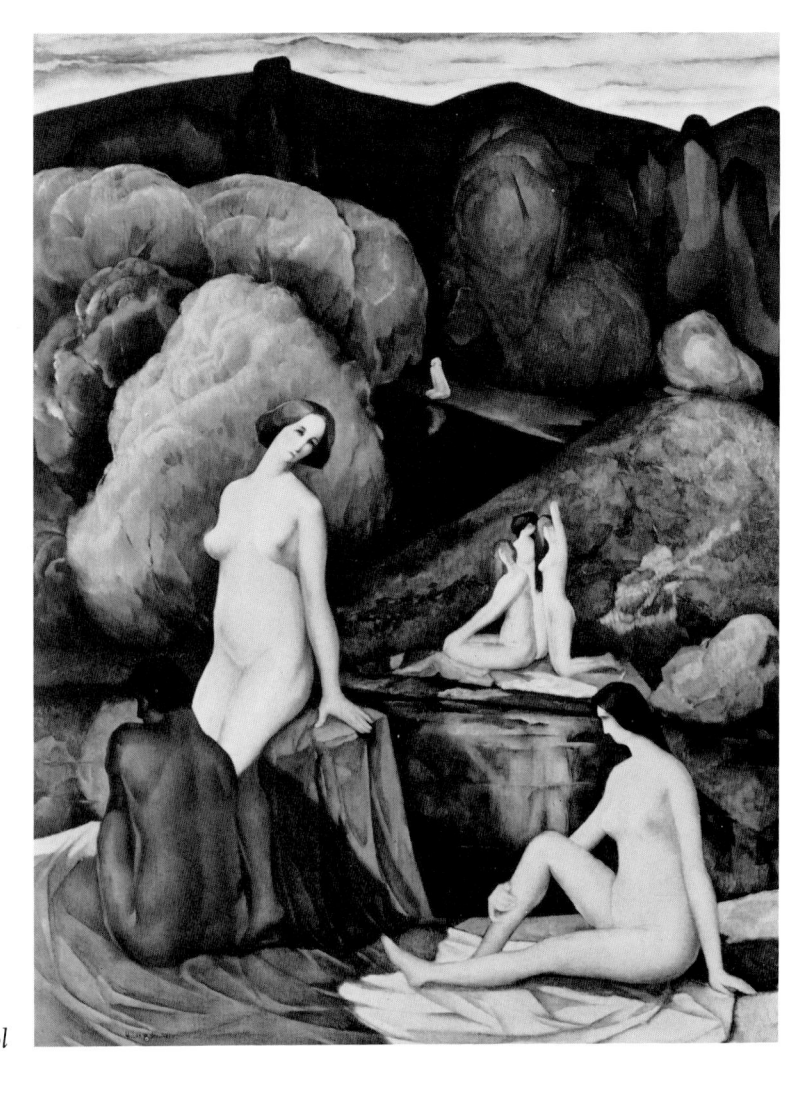

5. *The Swimming Pool*

21. *A Countryside*

Oil on canvas, 28 x 30 in. (71.1 x 76.2 cm.)

Signed, dated, and inscribed (at lower left): WILLIAM S. SCHWARTZ; (on the back): "A COUNTRYSIDE"/BY/WILLIAM S. SCHWARTZ/1929/PAINTING #183

RECORDED: J. Z. Jacobson, ed., "William S. Schwartz," in *Art of Today/Chicago, 1933* (1932), p. 121 illus.

EXHIBITED: The Art Institute of Chicago, Illinois, 1929, *Exhibition of Paintings and Lithographs by William S. Schwartz,* [n.p.] no. 10 // University of Wisconsin, Assembly Room of the Memorial Union, Madison, 1929, *Exhibition of Paintings by William Schwartz,* [n.p.] no. 29 // The Little Gallery, Cedar Rapids, Iowa, 1930, *An Exhibition of the Progressive Art of William S. Schwartz, Modernist,* [n.p.] no. 4 // Municipal Art Gallery, Davenport, Iowa, The Oshkosh Public Museum, Wisconsin, The Kansas City Art Institute, Missouri, The Museum of Fine Arts, Houston, Texas, and The Public Art Gallery, Dallas, Texas, 1930-31, *Paintings and Lithographs by William S. Schwartz*

EX COLL: Mrs. Arthur Kramer, Dallas, Texas; by gift to The Dallas Museum of Fine Arts, 1931–83

22. *Making a Lithograph*

Oil on canvas, 30 x 40 in. (76.2 x 101.6 cm.)

Signed, dated, and inscribed, (at lower center): WILLIAM S. SCHWARTZ; (on the back): "MAKING A LITHOGRAPH"/BY/ WILLIAM S. SCHWARTZ/CHICAGO/ 1929/PAINTING #178

4. *Death of a Mermaid*

RECORDED: Harry Wood, "Angles, Kaleidoscopic Colors Shock, Please Art Lovers," in *The Daily Cardinal,* Nov. 30, 1929 // Edward B. Rowan, "Art News of the Little Gallery," in *The Cedar Rapids Evening Gazette and Republican,* Feb. 21, 1930 // Florrie Ann Tams, "Weird Canvases in One-Man Art Show Carry Message of Ultra-Radicalist—Schwartz," in *Davenport Democrat and Leader,* March 21, 1930, p. 13 // Luigi Vaiani, "Art News," in *Kansas City Journal-Post,* Nov. 9, 1930 // "New Exhibition Opens at the Art Museum Today," in *Houston Post-Dispatch,* Dec. 7, 1930

EXHIBITED: The Art Institute of Chicago, Illinois, 1929, *Exhibition of Paintings and Lithographs by William S. Schwartz,* [n.p.] no. 6 // University of Wisconsin, Assembly Room of the Memorial Union, Madison, 1929, *Exhibition of Paintings by William Schwartz,* [n.p.] no. 26 // The Little Gallery, Cedar Rapids, Iowa, 1930, *An Exhibition of the Progressive Art of William S. Schwartz, Modernist,* [n.p.] no. 1 // Municipal Art Gallery, Davenport, Iowa, The Oshkosh Public Museum, Wisconsin, The Kansas City Art Institute, Missouri, The Museum of Fine Arts, Houston, Texas, The Public Art Gallery, Dallas, Texas, and University of Nebraska, Lincoln, 1930-31, *Paintings and Lithographs by William S. Schwartz*

23. *Resting*

Oil on canvas, 54⅛ x 34¾ in. (137.5 x 86.3 cm.)

Signed and inscribed (at lower right): WILLIAM S. SCHWARTZ; (on the back): "RESTING"/BY WILLIAM S. SCHWARTZ/ PAINTING # 265/CHICAGO; (on the stretcher): "RESTING"/BY/WILLIAM S. SCHWARTZ/Painting #265

Painted in 1931

EXHIBITED: The Art Institute of Chicago, Illinois, 1935, *Exhibition of Paintings and Lithographs by William S. Schwartz,* [n.p.] no. 16

16. *The Old Monastery Wall*

24. *Symphonic Forms #9*

Oil on canvas, 24 x 20 in. (61 x 50 cm.)

Signed and inscribed (at lower left): WILLIAM S. SCHWARTZ; (on the stretcher): SYM-PHONIC FORMS #9/BY WILLIAM S. SCHWARTZ/CHICAGO/PAINTING #279

Painted in 1932

EXHIBITED: The Art Institute of Chicago, Illinois, 1935, *Exhibition of Paintings and Lithographs by William S. Schwartz*, [n.p.] no. 7

EX COLL: Dr. and Mrs. Clarence Cohn, Chicago, Illinois; to Mr. and Mrs. Robert Helford, Des Plaines, Illinois

*25. *Symphonic Forms #10*

Oil on canvas, 20 x 24 in. (50.8 x 61 cm.)

Signed and inscribed (at lower center): WILLIAM S. SCHWARTZ; (on the back): "SYMPHONIC FORMS #10"/BY/WILLIAM S. SCHWARTZ/CHICAGO/PAINTING #280

Painted in 1932

EXHIBITED: The Art Institute of Chicago, Illinois, 1935, *Exhibition of Paintings and Lithographs by William S. Schwartz*, [n.p.] no. 8

26. *Symponic Forms #16*

Oil on canvas, 36⅛ x 40 in. (91.7 x 101.6 cm.)

Signed and inscribed (at lower right): WILLIAM S. SCHWARTZ; (on the back): "SYMPHONIC FORMS #16"/BY/WILLIAM S. SCHWARTZ/PAINTING #286/ CHICAGO; (on the stretcher): "SYM-PHONIC FORMS #16"/BY/WILLIAM S. SCHWARTZ/CHICAGO/PAINTING #286

Painted in 1932

RECORDED: Frank Holland, "Schwartz Exhibition Reveals High Style," in *The Chicago Sun*, Oct. 6, 1946

EXHIBITED: The Art Institute of Chicago, Illinois, 1935, *Exhibition of Paintings and Lithographs by William S. Schwartz*, [n.p.] no.

11 // Flint Institute of Art, Michigan, 1935, *Works of Six Chicago Artists* // Memorial Gallery of Art, Rochester, New York, 1936, *A Group Exhibition by Four from Chicago: Francis Chapin, Walter Krawiec, William Schwartz, and Aaron Bohrod* // The Associated American Artists Galleries, New York, 1943, *Exhibition of Paintings and Lithographs by William S. Schwartz,* [n.p.] no. 11

27. *Symphonic Forms #17*

Oil on canvas, 18½ x 48 in. (46 x 122 cm.)

Signed and inscribed (at lower right): WILLIAM S. SCHWARTZ; (on the back): "SYMPHONIC FORMS #17"/BY/WILLIAM S. SCHWARTZ/PAINTING #287/CHICAGO; (on the stretcher): SYMPHONIC FORMS #17/BY/WILLIAM S. SCHWARTZ/CHICAGO/PAINTING #287

Painted in 1932

EXHIBITED: The Art Institute of Chicago, Illinois, 1935, *Exhibition of Paintings and Lithographs by William S. Schwartz,* [n.p.] no. 12 // Flint Institute of Art, Michigan, 1935, *Works of Six Chicago Artists* // Memorial Gallery of Art, Rochester, New York, 1936, *A Group Exhibition by Four from Chicago: Francis Chapin, Walter Krawiec, William Schwartz, and Aaron Bohrod*

*28. *Symphonic Forms #18*

Oil on canvas, 40 x 36⅛ in. (101.6 x 91.8 cm.)

Signed and inscribed (at lower left): WILLIAM S. SCHWARTZ; (on the back): "SYM-PHONIC FORMS #18"/BY/WILLIAM S. SCHWARTZ; (on the stretcher): SYM-PHONIC FORMS #18/BY/WILLIAM S. SCHWARTZ/CHICAGO/PAINTING #288

Painted in 1932

*29. *Modern Transportation of Mail*

Oil on canvas, 18 x 34 in. (45.7 x 86.3 cm.)

Signed and inscribed (on the back): WILLIAM S. SCHWARTZ; (on the front, at lower left): LEFT HAND PANEL; (on the back stretcher): 1/PAINTING #333

Painted in 1932

During the 1930s Schwartz painted murals under the Treasury Department "Section" of the WPA/FAP. Intended as preliminary studies for a larger mural to illustrate the history of moving the United States mail, and titled in his ledger book "Sketch for Mural," these three studies were never worked up into a full-scale mural.

*30. *Early Transportation of Mail*

Oil on canvas, 18 x 34 in. (45.7 x 86.3 cm.)

Signed and inscribed (on the back): WILLIAM S. SCHWARTZ; (on the front, at lower center): EARLY TRANSPORTATION OF MAIL; (on the stretcher): PAINTING #2/333

Painted in 1932

*31. *Transportation of Mail*

Oil on canvas, 18 x 34 in. (45.7 x 86.3 cm.)

Signed and inscribed (on the back): WILLIAM S. SCHWARTZ; (on the front, at lower right): RIGHT HAND PANEL; (on the stretcher): PAINTING #3/333

Painted in 1932

32. *Come to Me All Ye That Are Heavy Laden*

Oil on canvas, 40 x 50 in. (101.6 x 127 cm.)

Signed and inscribed (at lower center): WILLIAM S. SCHWARTZ; (on the back): "COME TO ME ALL YE THAT ARE HEAVY LADEN"/BY/WILLIAM S. SCHWARTZ-PAINTING #321

Painted in 1934

*33. *Autobiography*

Oil on canvas, 30 x 23¹⁵⁄₁₆ in. (76.2 x 60.8 cm.)

Signed and inscribed (at lower left): WILLIAM S. SCHWARTZ; (on the back): "AUTO-BIOGRAPHY"/BY/WILLIAM S. SCHWARTZ/CHICAGO/PAINTING #334

Painted in 1935

Autobiography depicts the artist and his future wife Mona Turner his studio. Schwartz met Mona about 1929; they were married in 1939. Mona was an essential part of Schwartz's life and career. For the duration of their married life, until Schwartz's death in 1977, she diligently took responsibility for all administrative aspects of his career, including appointments, accounts, clipping files, as well as modeling.

30. *Early Transportation of Mail*

29. *Modern Transportation of Mail*

31. *Transportation of Mail*

34. *Self-Portrait*

37. *Portrait of a Young Man (Ric Riccardo)*

DRAWINGS AND LITHOGRAPHS

*34. *Self-Portrait*

Conté crayon on grey paper, 14½ x 10⅞ in. (36.9 x 27.7 cm.)

Signed and inscribed (at lower left): W.S. Schwartz; (on the back): Exhibited at the/ Kansas City Art Institute 1932/Houston Museum of Fine Arts 1932/Dallas Museum of Fine Arts 1932/Little Gallery, Cedar Rapids, Iowa 1932/ University of Missouri, Columbia 1933/Texas State College for Women, Denton 1933

Executed between 1925 and 1932

35. *Day Dreaming*

Pastel on paper, 14½ x 11 in. (36.8 x 28 cm.)

Executed between 1925 and 1932

Day Dreaming is one in a series of figure drawings that Schwartz executed in pastel and pencil between 1925 and 1932. These drawings, notational sketches of models in varying poses and attire, often served as studies for figures in lithographs and paintings.

*36. *The Gas Factory*

Conté crayon on paper, 12½ x 16½ in. (31.8 x 41.9 cm.)

Signed, dated, and inscribed (at lower left): WILLIAM S. SCHWARTZ 1927; (on the back): EXHIBITED IN THE EIGHTH INTER-NATIONAL WATER/COLOR SHOW—AT THE ART INSTITUTE OF CHICAGO 1928/ "GAS FACTORY"

EXHIBITED: The Art Institute of Chicago, Illinois, 1928, *The Eighth International Exhibition Water Colors, Pastels, Drawings, Miniatures,* [n.p.] no. 313

Schwartz first painted this subject in 1926 (collection of James D'Agostino, Los Angeles, California). Executed one year later, this drawing (the same image) served as the preliminary study for *Lithograph #5* (cat. no. 46).

*37. *Portrait of a Young Man (Ric Riccardo)*

Pencil on buff paper, 19 x 15 in. (48.3 x 38.1 cm.)

Signed and dated (at lower right): WILLIAM S. SCHWARTZ 1927

A painter, art patron, gallery owner, and personal friend of Schwartz's, Ric Riccardo played an active role in the Chicago art community during his lifetime. In 1948 he commissioned six of Chicago's most prominent artists, Schwartz, Malvin and Ivan Albright, Aaron Bohrod, Vincent D'Agostino, and Rudolph Weisenborn, to paint panels depicting the "Seven Lively Arts" for a café adjoining his popular restaurant at 437 Rush Street. For this program Schwartz contributed a large vertical panel titled "Music," an abstract composition stylistically related to his extensive series of "Symphonic Forms."

38. *Study of a Man*

Conté crayon on buff paper, 17¾ x 14¾ in. (45.1 x 37.5 cm.)

Signed and dated (at lower right): WILLIAM S. SCHWARTZ 1927

*39. *Study of a Standing Man*

Conté crayon on paper, 14¼ x 7⅝ in. (36.2 x 19.3 cm.)

Signed (at lower right): W.S.S.

Executed about 1927

Standing Man served as a preliminary study for the male figure in the center right-hand passage of *After Working Hours* (cat. no. 14). In his earliest paintings from the 1920s, Schwartz often conceived of figures as symbolic representations of diverse social classes, recalling his adolescence in Smorgon, Russia. *Standing Man* is a pictorial archetype representing a working class laborer or fisherman.

39. *Study of a Standing Man*

40. *Female Nude*

 Conté crayon on paper, 19⅛ x 11¾ in. (48.6 x 29.7 cm.)

 Signed and dated (at lower center): WILLIAM S. SCHWARTZ/1928

41. *Abstract Female Form*

 Conté crayon on paper, 19½ x 11¾ in. (49.5 x 29.9 cm.)

 Signed and dated (at lower left): WILLIAM S. SCHWARTZ 1928

42. *Female Torso*

 Conté crayon on paper, 14¼ x 8⅜ in. (36.2 x 21.3 cm.)

 Signed and dated (at lower right): WILLIAM S. SCHWARTZ/1928

 Female Torso served as the preliminary drawing for *Lithograph #4*, executed the same year.

43. *Sitting Nude*

 Conté crayon on paper, 13⅞ x 10⅞ in. (35.3 x 27.7 cm.)

 Signed, dated, and inscribed (at lower right): WILLIAM S. SCHWARTZ—1928; (on the back): SITTING NUDE 32

 Sitting Nude served as the preliminary drawing for *Lithograph #22* (cat. no. 50).

*44. *The Dancer*

 Conté crayon on paper, 20⅜ x 14½ in. (50.8 x 36.9 cm.)

 Signed and dated (at lower left): WILLIAM S. SCHWARTZ 1928

 The Dancer served as the preliminary drawing for *Lithograph #24*, executed in 1929.

*45. *Two Nudes*

 Pencil on paper, 11⅞ x 19¾ in. (30.3 x 50.2 cm.)

 Signed and dated (at lower right): WILLIAM S. SCHWARTZ/1928

 Two Nudes, a contour drawing, served as the preliminary study for *Lithograph #26* (cat. no. 51).

46. *Lithograph #5 (Gas Factory)*

Lithograph, 13⅞ x 17¾ in. (35.3 x 45.1 cm.)

Signed, dated, and inscribed (in pencil, at lower right): William S. Schwartz; (at lower left): LITHOGRAPH # 5 IMPRESSION #11; (in the stone, at lower left): WILLIAM S. SCHWARTZ—1928

Edition of 20

RECORDED: *cf.* Hazel Boyer Braun, "Art Comment," in *The Evening Tribune,* March, 1931 // *cf.* Manuel Chapman, *William S. Schwartz: A Study* (1930), p. 231 illus.

EXHIBITED: *cf.* The Art Institute of Chicago, Illinois, 1935, *Exhibition of Paintings and Lithographs by William S. Schwartz,* [n.p.] no. 37

*47. *Lithograph #10 (Dwellings along the River)*

Lithograph, 16¾ x 17½ in. (42.6 x 44.5 cm.)

Signed, dated, and inscribed (in pencil, at lower right): William S. Schwartz; (in pencil, at lower left): LITHOGRAPH #10 IMP. #22; (in pencil, on the back): LITHOGRAPH #10 IMPRESSION #22; (in the stone, at lower right): WILLIAM S. SCHWARTZ/1928

Edition of 22

RECORDED: *cf.* V.T., "An Omahan in the World of Art: An Estimate of William S. Schwartz," in *Sunday World-Herald,* Jan. 4, 1931 // *cf.* Florence Davies, "Art and Autobiography," in *The Detroit News,* April 5, 1931 // *cf.* Manuel Chapman, *William S. Schwartz: A Study* (1930), p. 237 illus.

36. *The Gas Factory*

EXHIBITED: *cf.* The Art Institute of Chicago, Illinois, 1935, *Exhibition of Paintings and Lithographs by William S. Schwartz,* [n.p.] no. 38

Lithograph #10 is based on the painting titled *Dwellings along the River* (cat. no. 18). In the lithograph, the image is simplified through black and white contrast; surface clarity replaces the subdued modeling of the painting.

*48. *Lithograph #16*

Lithograph, 22⁵⁄₁₆ x 17¹⁄₁₆ in. (59.2 x 43.3 cm.)

Signed, dated, and inscribed (in pencil, at lower left): William S. Schwartz/LITHOGRAPH #16 IMPRESSION #2; (in the stone, at lower right): WILLIAM S. SCHWARTZ—1928

Edition of 26

RECORDED: *cf.* Marguerite B. Williams, "Lithography, A New Interest," in *The Chicago Daily News,* Oct. 17, 1928 // *cf.* J. Z. Jacobson, "Art at the Institute," in *The Chicagoan,* Sept. 17, 1929 // *cf. Earth* I (April 1930), p. 4 illus. // *cf.* Manuel Chapman, *William S. Schwartz: A Study* (1930), p. 149 illus.

EXHIBITED: *cf.* The Jewish Center's Association, Temple Beth-El, Chicago, Illinois, 1929-30, *Ninth Annual Art Exhibition,* [n.p.] no. 27 // *cf.* Jewish People's Institute, Chicago, Illinois, 1930, *Seventh Annual Exhibition of the Works of Jewish Artists of Chicago,* [n.p.] no. 83

49. *Lithograph #18 (Mandrake)*

Lithograph, 18¾ x 12¼ in. (47.7 x 31.1 cm.)

Signed, dated, and inscribed (in pencil, at lower right): William S. Schwartz; (on the back): LIT #18 IMP #3; (in the stone, at lower left): WILLIAM S. SCHWARTZ—1928

Edition of 25

RECORDED: *cf.* Marguerite B. Williams, "Lithography, A New Interest," in *The Chicago Daily News,* Oct. 17, 1928 // *cf.* Charles Victor Knox, "Schwartz Lithographs," in *The Chicago Evening Post Magazine of the Art World,* Feb. 22, 1929 // *cf.* Manuel Chapman, *William S. Schwartz: A Study* (1930), p. 157 illus. // *cf.* Letter, Mildred Bentiss (Acting Curator of Prints, The Art Institute of Chicago) to William Schwartz, Feb. 13, 1930 (unpub. ms., Schwartz Papers, Des Plaines, Illinois)

45. *Two Nudes*

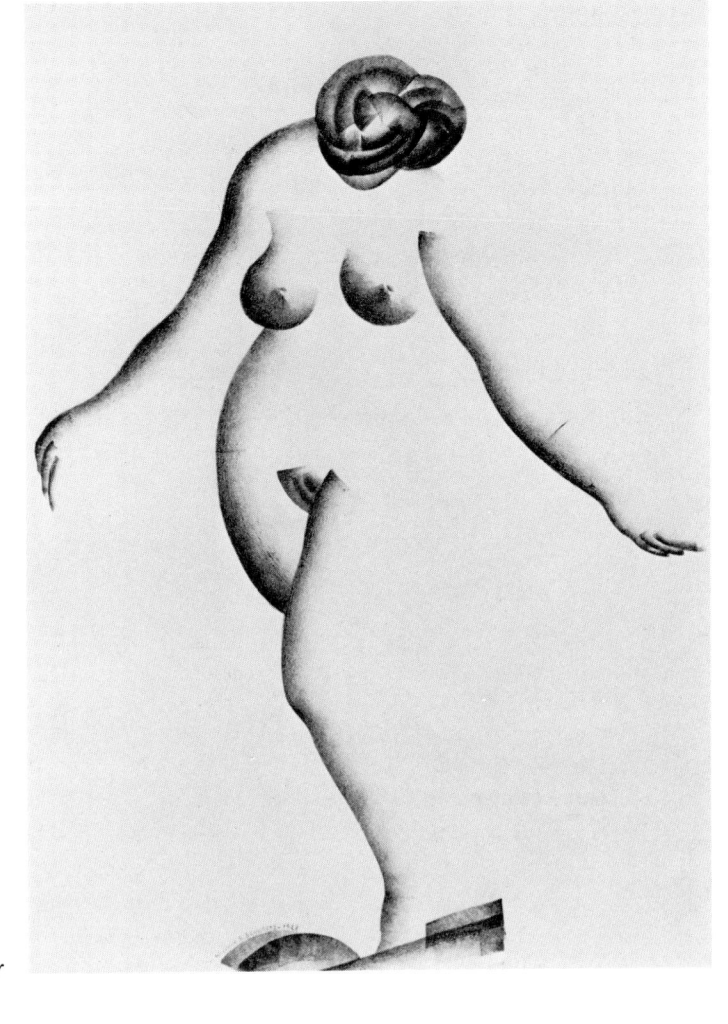

44. *The Dancer*

EXHIBITED: *cf.* The Jewish Center's Association, Temple Beth-El, Chicago, Illinois, 1929-30, *Ninth Annual Art Exhibition,* [n.p.] no. 28 // *cf.* The Art Institute of Chicago, Illinois, 1929-30, *First International Exhibition of Lithography and Wood Engraving,* [n.p.] no. 359

50. *Lithograph #22*

Lithograph on buff paper, 17⅛ x 11¼ in. (43.3 x 28.6 cm.)

Signed, dated, and inscribed (in the stone, at lower right): WILLIAM S. SCHWARTZ—1929; (in pencil, at lower left): LITHOGRAPH #22 IMPRESSION #10

Edition of 21

RECORDED: *cf.* Luigi Vaiani, "Art News," in *Kansas City Journal-Post,* Nov. 9, 1930 // *cf.* Dorothy Grafly, "Schwartz Litho Show Initiative," in *Public Ledger-Philadelphia,* Nov. 16, 1930 // *cf.* Manuel Chapman, *William S. Schwartz: A Study* (1930), p. 233 illus.

EXHIBITED: *cf.* The Art Institute of Chicago, Illinois, 1935, *Exhibition of Paintings and Lithographs by William S. Schwartz,* [n.p.] no. 39

51. *Lithograph #26*

Lithograph, 10½ x 15¼ in. (26.7 x 38.7 cm.)

Signed, dated, and inscribed (in pencil, at lower left): William S. Schwartz; (on the back): LIT #26 IMP #6; (in the stone, at lower right): WILLIAM S. SCHWARTZ 1929

Edition of 24

RECORDED: *cf.* Manuel Chapman, *William S. Schwartz: A Study* (1930), p. 253 illus.

54. *Lithograph #43 (Still Life—Fruit)*

*52. *Lithograph #41 (Visionary City)*

Lithograph, 19 x 15 in. (48.2 x 38.1 cm.)

Signed and inscribed (in the stone, at lower right): WILLIAM S. SCHWARTZ; (in pencil, at lower left): LITHOGRAPH #41; (on the back): LIT #41 IMP #10.

Edition of 22

Executed in 1931

53. *Lithograph #42 (The Old Monastery Wall)*

Lithograph, 12¾ x 16 in. (32.4 x 40.6 cm.)

Signed and inscribed (in the stone, at lower right): WILLIAM S. SCHWARTZ; (in pencil, at lower left): LITHOGRAPH #42; (in pencil, on the back): LIT #42 IMP #17

Edition of 22

Executed in 1931

EXHIBITED: *cf.* The Pennsylvania Academy of the Fine Arts, Philadelphia, 1934, *The Thirty-Second Annual Water Color Exhibition and the Thirty-Third Annual Exhibition of Miniatures,* p. 86 no. 1238 // *cf.* The Art Institute of Chicago, Illinois, 1935, *Exhibition of Paintings and Lithographs by William S. Schwartz,* [n.p.] no. 44 // *cf.* Oklahoma WPA Art Center, 1940, *The Second Annual Competitive Exhibition of Lithograpy,* p. 13 no. 336 // *cf.* Albright Art Gallery, Buffalo, New York, 1940, *Third National Print Show of the Buffalo Print Club,* [n.p.] [n.n.] // *cf.* The Metropolitan Museum of Art, New York, 1942, *Artists for Victory: An Exhibition of Contemporary American Art,* p. 49 [n.n.]

Lithograph #42 is based on an earlier painting and its preliminary oil sketch, both titled *The Old Monastery Wall* (cat. nos. 15 and 16).

48. *Lithograph #16*

47. *Lithograph #10*
(Dwellings along the River)

*54. *Lithograph #43 (Still Life—Fruit)*

Lithograph, 20 x 18 in. (50.8 x 45.7 cm.)

Signed and inscribed (in pencil, at lower left): William S. Schwartz; (in pencil, on the back): LITHO #43—IMP. #33; (in the stone, at lower left): WILLIAM S. SCHWARTZ

Edition of 73

Executed in 1931

RECORDED: *cf.* Albert TenEyck Gardner, "Art for the Public," in *Magazine of Art* (Sept. 1938), p. 531, as "Fruit" // *cf.* Letter, Edward Hendy (Executive Treasurer, National Academy of Design, New York) to William Schwartz, Aug. 1, 1943 (unpub. ms., Schwartz Papers, Des Plaines, Illinois)

EXHIBITED: *cf.* The Art Institute of Chicago, Illinois, 1931-32, *Third International Exhibition of Lithography and Wood Engraving,* [n.p.] no. 280 // *cf.* Whitney Museum of American Art, New York, 1933, *Paintings and Prints by Chicago Artists,* p. 11 no. 111 // *cf.* The Pennsylvania Academy of the Fine Arts, Philadelphia, 1934, *The Thirty-Second Annual Water Color Exhibition and The Thirty-Third Annual Exhi-bition of Miniatures,* p. 86 no. 1242 // *cf.* The Art Institute of Chicago, Illinois, 1935, *Exhibition of Paintings and Lithographs by William S. Schwartz,* [n.p.] no. 45 // *cf.* Oklahoma Art Center, Nebraska, 1939, *The First Annual Competitive Exhibition of Lithography,* p. 10 no. 231 // *cf.* Albright Art Gallery, Buffalo, New York, 1940, *Third National Print Show of the Buffalo Print Club,* [n.p.] [n.n.] // *cf.* The Metropolitan Museum of Art, New York, 1942, *Artists for Victory: An Exhibition of Contemporary American Art,* p. 49 [n.n.]

55. *Lithograph #44 (Mona)*

Lithograph, 15½ x 10¼ in. (39.4 x 26 cm.)

Signed and inscribed (in pencil, at lower left): William S. Schwartz; (in pencil, on the back): LIT #44 IMP #2; (in the stone, at lower right): WILLIAM S. SCHWARTZ

Edition of 27

Executed in 1932

RECORDED: *cf. The Daily Oklahoman,* Dec. 24, 1933, illus.

33. *Autobiography*

GALLERY SERVICES

In addition to selling works of art of the highest quality, Hirschl & Adler Galleries also offers its expert services in the areas of appraising, restoration, conservation, and framing. Our staff is available to appraise single works of art or entire collections. We are also able to recommend and execute the proper restoration or conservation work, or assist in the selection of the appropriate antique or museum-quality reproduction frame to set off your picture to its greatest advantage.

Printed by Colorcraft Lithographers, Inc., New York
Type set by Compo-Set Typographers, Inc., New York